MUCHA

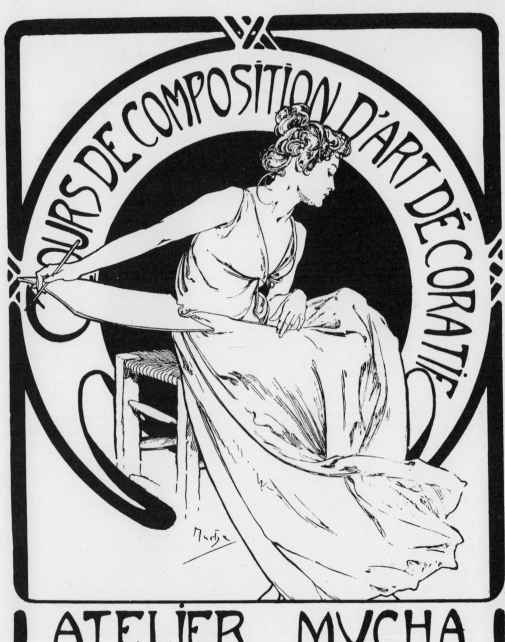

COURS DE COMPOSITION D'ART DÉCORATIF

ATELIER MVCHA

PROSPECTUS FOR ATELIER MUCHA 1896

MUCHA

ALL COLOUR PAPERBACK

ACADEMY EDITIONS·LONDON

ACKNOWLEDGEMENTS

We should like to thank Jiri Mucha for his permission to reproduce the illustrations contained in this book; Camden Graphics for supplying colour separations for plates 2, 4, 5, 10, 17, 28, 35, 36, 37, 38, 41, 46 and 48; and Editions Graphiques for plates 6, 9 and 40. We are also grateful to Mrs. Sheila More for her help, and to Galerie Documents, Paris for providing a photograph of the poster of *Cycles Perfecta* in their possession.

First published in Great Britain by
Academy Editions, 7 Holland Street, London W8

© 1976 by Academy Editions

ISBN: 85670 303 6

Printed and bound in Great Britain by
Cox & Wyman Ltd, Fakenham

O n Christmas Eve 1894, while correcting proofs for his friend Kadár in the offices of Lemercier et Cie in Paris, Alphonse Marie Mucha was asked by the director of the company, Maurice de Brunhoff, through want of another artist, to design a poster featuring Sarah Bernhardt for Sardou's play *Gismonda*. That same night Mucha made studies of Bernhardt at the Theatre de la Renaissance and afterwards sketched the first design on a marble table top in a nearby café. All the elements which were to make the poster an instant success — accentuated contours, curves and circles, the decorative use of natural features, and formalized stars and mosaic motifs — were all present in this first crude sketch. When the full-scale design in distemper on canvas was shown to Bernhardt she was delighted, and it was a tribute to Mucha, in an age of great poster artists like Cherèt and Toulouse-Lautrec, that Bernhardt felt that her *dramatis persona* had been successfully captured in graphic form for the first time.

Mucha's son, Jiri, has suggested that it was the combination of the power of Bernhardt's personality and the emotional force of the scene in which his father chose to depict her which acted as a catalyst on the diverse influences of his artistic development. Because of the great urgency for the poster, Mucha drew the design directly onto the lithographic plate, and it was produced so quickly — between December 24th and January 1st 1895 — that the lower half was not finished to the same degree as the upper half.

The success of the *Gismonda* poster seems the more remarkable for Mucha's lack of experience in this field, his existing work, other than some mural and scene painting, consisting of illustrations for Xavier Marmier's *Les Contes des Grand-Mères* and Seignobo's *Scenes et Episodes de L'Histoire D'Allemagne*. Nor was there anything remarkable about Mucha's previous work to distinguish it from that of the academies or from the majority of his contemporaries. *Gismonda* seemed to herald a new style, its strength lying in the restrained use of colour — rose, violet, green, brown and gold — and in the sensitive line of the drawing. Bernhardt is portrayed standing holding a palm-leaf, her head framed by a Byzantine mosaic frieze containing Bernhardt's name and above which the title of the play appears. Bernhardt is draped in garments which reveal a Renaissance, Central European or possibly Hispano-Moresque influence in the treatment of their embroidery. Mucha himself denied any direct influence on his work other than the traditions of folk-ornamentation of his native Czechoslovakia. But a number of influences are apparent: whether the *cloissonism* — the surrounding of the colour area with a dark contour to enhance the expressive movement of the line and the glow of the colour — of Paul Gauguin and Eugene Grasset; the kinetic treatment

of curvilinear motifs as in the work of Burne-Jones, Ricketts, Beardsley, Toorop, van de Velde and Horta; the formalized stars and technique of elongation of Carlos Schwabe, especially his Rosicrucian poster design; the linear conventions of Moorish architecture and Islamic design; or the flat, stylised treatment of draperies in Japanese woodcuts. He had little in common with the contemporary Realist and Impressionist schools in Paris, being primarily a stylist and linearist not concerned with problems of chiaroscuro, texture, tonal relationship or fidelity to the subject as with contours and the development of line an in intricate and expressive pattern. To this end Mucha employed photography to assist him in his designs, not to document the details of his subject but to capture the broad outlines of a pose, drapery, for example, being modified in the finished work to fall in a continuous dynamic sweeping movement. Nor was he a great inventor, the basis of his art residing in a wide ranging eclecticism, his originality lying in his ability to transform his borrowings into something quite extraordinarily striking and different through his sensitive draughtmanship and unique appreciation of colour. Mucha's sense of amplitude and the wider application of existing motifs extended the possibilities of a stylistic vocabulary discovered earlier in the 19th century.

The recognition which the *Gismonda* poster brought was followed by years of hard work. The period 1895 to 1897, when he was working for Bernhardt and under contract to the printing firm of Champenois, was especially prolific. It was during this time that he produced many of the *panneaux decoratifs,* calendars, advertisements and menu-cards reproduced in the following pages. Each of the *panneaux* — small posters printed on stiff paper or silk and used as decorative wall panels or screens — were originated through a series of studies until the final design was executed in pencil, crayon, pastel or watercolour. This was traced onto a lithographic stone and Mucha himself, at least in the early days, would colour the monochrome proofs.

Mucha's posters were usually of an elongated rectangular shape and often extending to seven feet in height, which in turn lent to his invariably female subject a form of svelte elegance which we now associate with fashion photography. Even in his own time Mucha was hailed as the supreme artist of women, the flattering portrayal of his model, as his extant photographs reveal, giving rise to what came to be known as the archetypal 'Mucha woman': young and beautiful, virginal yet sensuous and provocative, the voluptuous poses accentuated by the natural curves of the feminine figure. This inevitably led to the accusation that he was corrupting youth, a suggestion that becomes the more absurd when his work is compared with that of, say, Beardsley. In fact it was no accident that this charming ubiquitous creature should figure so prominently in the artist's work, for Mucha, like nature, abhors a vacuum, and the unification of otherwise 'dead' areas of the picture surface by the use of tendril-like patterns resulted from his conviction that the muscles of the human eye prefer to follow a curved rather than straight line, and that it was the artist's responsibility to stimulate the viewer by reproducing the natural harmony of curves (cf. *Cycles Perfecta* 1 and *La Plume* 25). The recurrent circular symbols in Mucha's repertoire are legion: the aureole (*Primevere* 24), the halo (*Job* advertisements), the crescent (*The Moon* 27), the 'Q' shape (*Documents Decoratifs* 16), co-axial circles with a common tangent (*Monaco -*

Monte Carlo 6), and usually used not so much as a convention with an identifiable meaning as an obsessional device with a decorative function. Mucha was acquainted with the work of the Symbolists, and in some cases his graphic designs were symbolist and allegorical in character, sometimes employing a combination of the sacred and profane more usually associated with Moreau and the Decadents. Mucha's compositional arrangements were also governed by his belief that the eye always found its natural focus when viewing any object along the axis of the 'Golden Mean,' the ratio of 2:3, and that the artist should always place the centre of his composition at this point.

Mucha at no time strove for popular acceptance and lacked the committment to revolt against accepted norms so common among his artist peers, and yet by the turn of the century his position had consolidated as France's most fashionable illustrator. It is no small irony that Mucha refused to accept the validity of the term 'Art Nouveau' arguing that "Art is eternal, it cannot be new" but consistently applying its principles to his own work, sharing its characteristics and yet remaining aloof from any movement. Between 1895 and 1905 his major published works were distinguished by a unity of conception and execution which led to the description in France of all work in the Art Nouveau style as being in *'le style Mucha.'* It is not surprising, therefore, that his own work should form one of the most comprehensive statements of Art Nouveau by any one artist. Mucha's oeuvre extended with time from the mixed media of theatre design — scenery, costumes and publicity material — to architecture, bank notes and even policemen's uniforms. But it is his graphic work for which he is primarily known and remembered, and the following plates are a testimony to the achievement of the most celebrated graphic artist of the *Belle Epoque.*

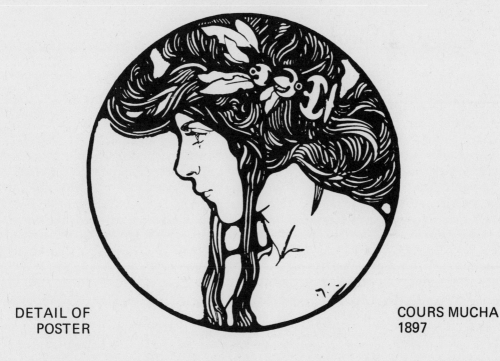

DETAIL OF
POSTER

COURS MUCHA
1897

1

CYCLES PERFECTA
c. 1897
150 x 105 cm / 60 x 41 in

2

CHOCOLAT IDEAL
c. 1897
117 x 78 cm / 47 x 31 in

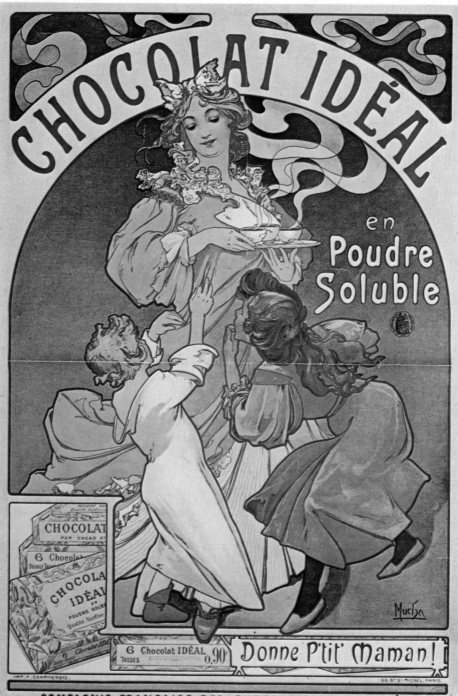

3

BLEU DESCHAMPS
c. 1897
50 x 33 cm / 20 x 13 in

4

PRINCESS HYACINTH
1911
117 x 78 cm / 47 x 31 in

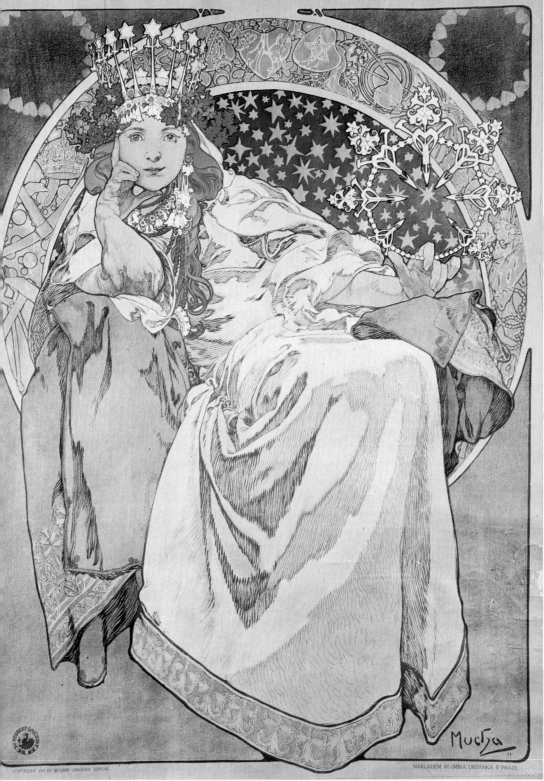

PRINCEZNA HYACINTA

NÁKLADEM MOJMÍRA URBÁNKA V PRAZE.

5

DICTIONNAIRE DES ARTS DECORATIFS
Paul Rouaix Paris 1902

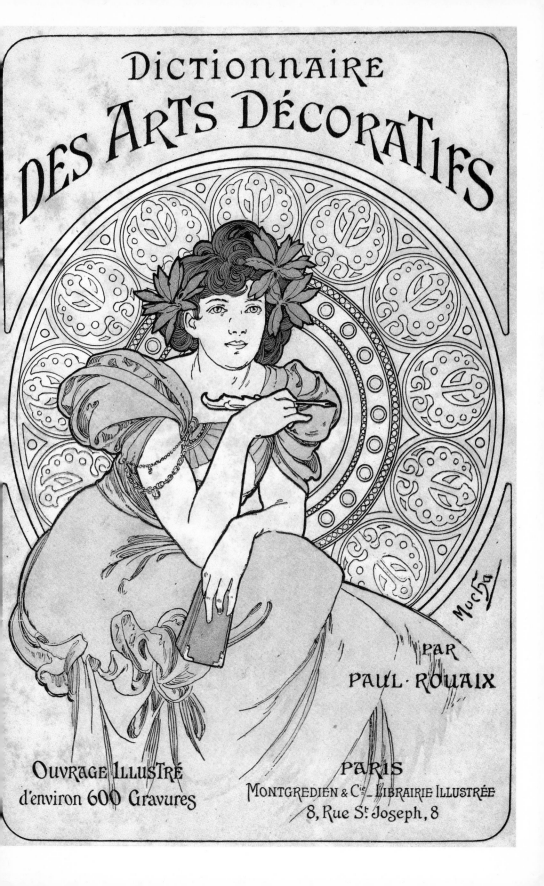

Dictionnaire
Des Arts Décoratifs

PAR

PAUL · ROUAIX

OUVRAGE ILLUSTRÉ
d'environ 600 Gravures

PARIS
MONTGREDIEN & Cie — LIBRAIRIE ILLUSTRÉE
8, Rue St Joseph, 8

6

MONACO - MONTE CARLO
1897
110 x 76 cm / 43 x 30 in

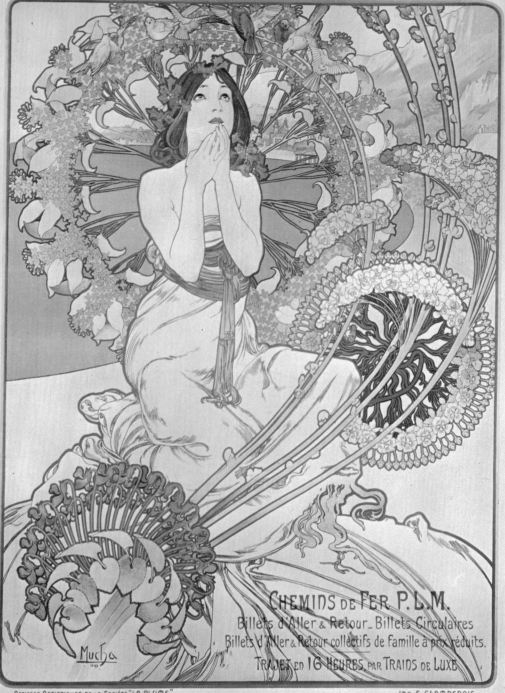

7

CHOCOLAT MASSON
CHOCOLAT MEXICAIN
1897
42 x 58 cm / 14 x 23 in

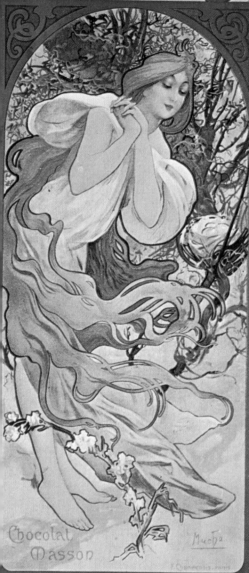

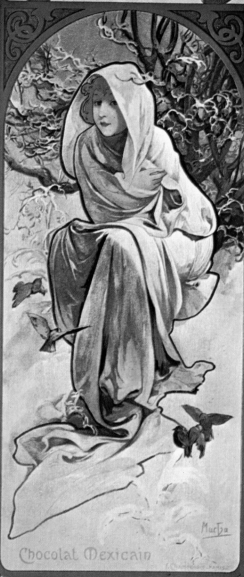

8

CHOCOLAT MASSON
CHOCOLAT MEXICAIN
1897
42 x 58 cm / 14 x 23 in

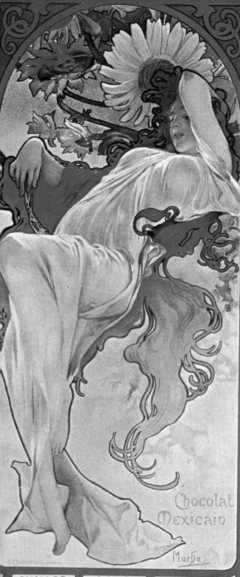
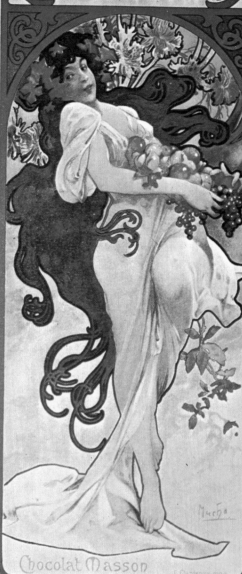

9

OESTERREICH AUF DER
WELTAUSSTELLUNG PARIS 1900
96 x 63 cm / 38 x 25 in

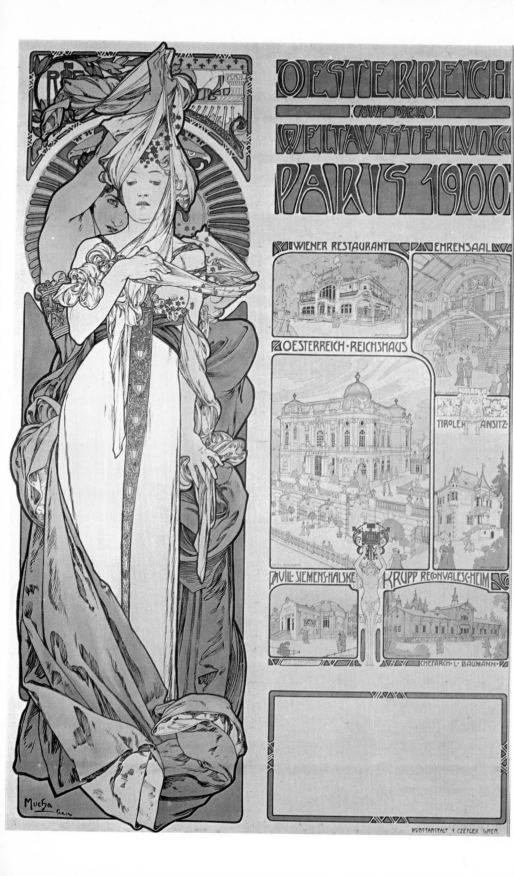

10

Y W C A
c. 1922
66 x 37 cm / 26 x 15 in

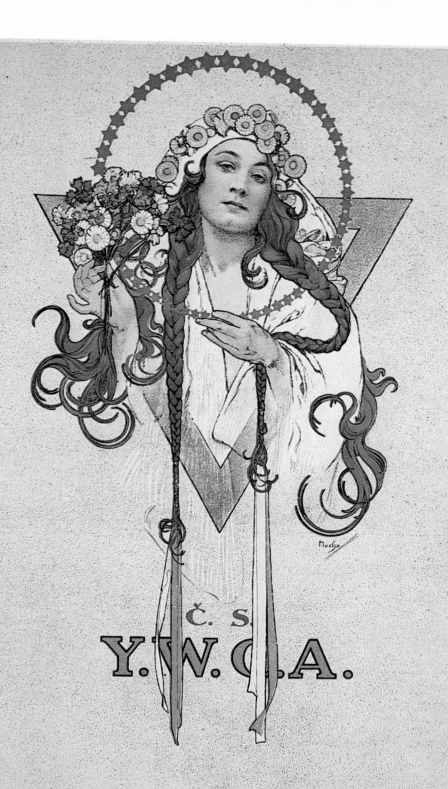

Č. S.

Y.W.C.A.

11

LA DAME AUX CAMELIAS
1896
201 x 69 cm / 79 x 27 in

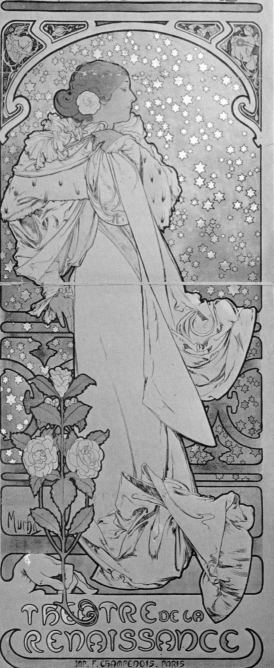

12

GISMONDA
1894
213 x 75 cm / 84 x 30 in

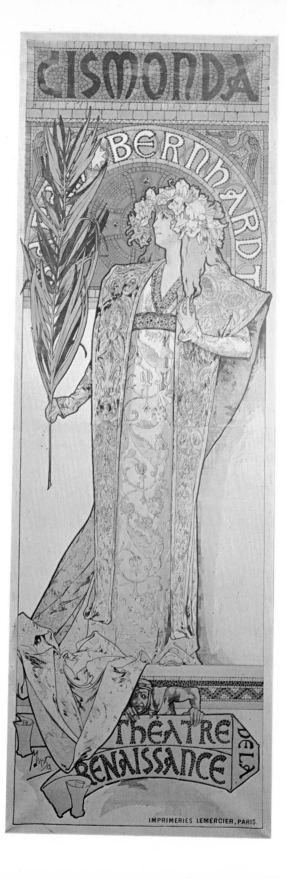

13

IMPRIMERIE CASSAN FILS
1897
166 x 59 cm / 65 x 23 in

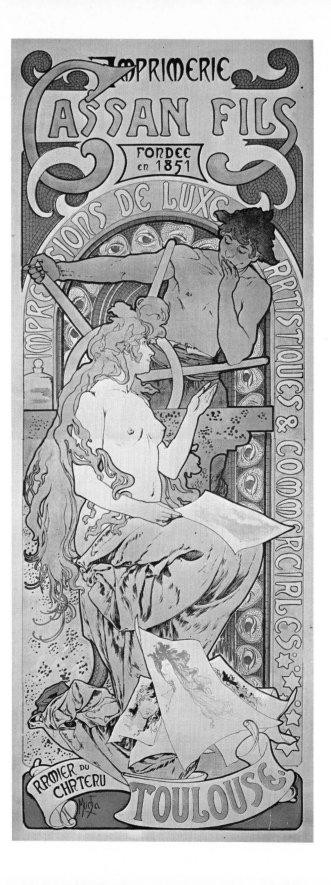

14

**MOET & CHANDON
IMPERIAL
1899
58 x 19 cm / 23 x 7 in**

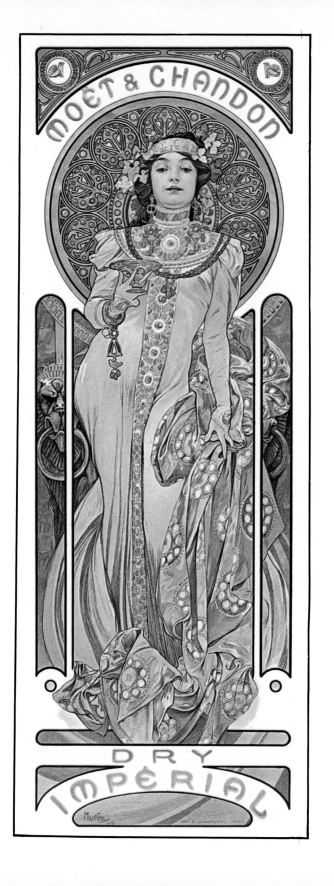

15

NECTAR
1899
64 x 26 cm / 25 x 10 in

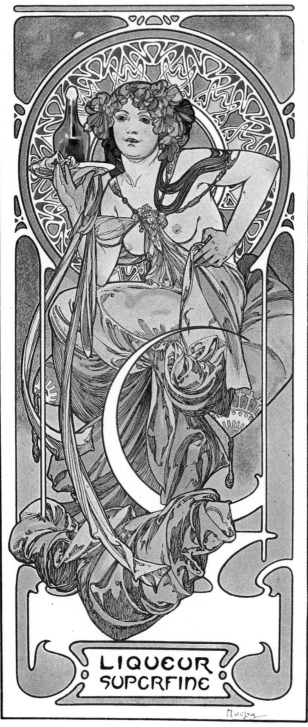

16

DOCUMENTS DECORATIFS
Librairie Centrale des Beaux-Arts
Paris 1902

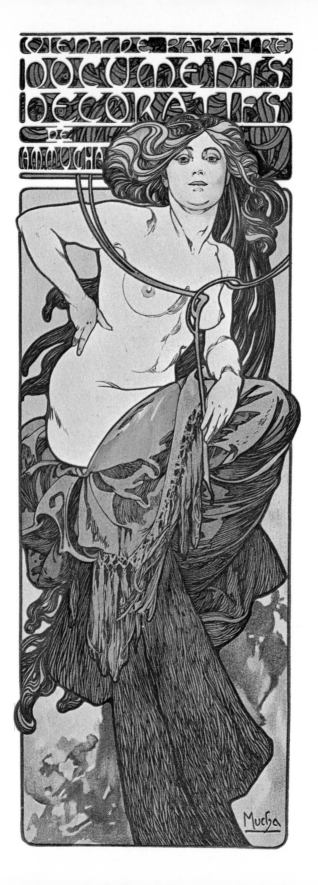

17

TETE BYZANTINE-BRUNETTE
Panneau
c. 1897
34 x 28 cm / 13 x 11 in

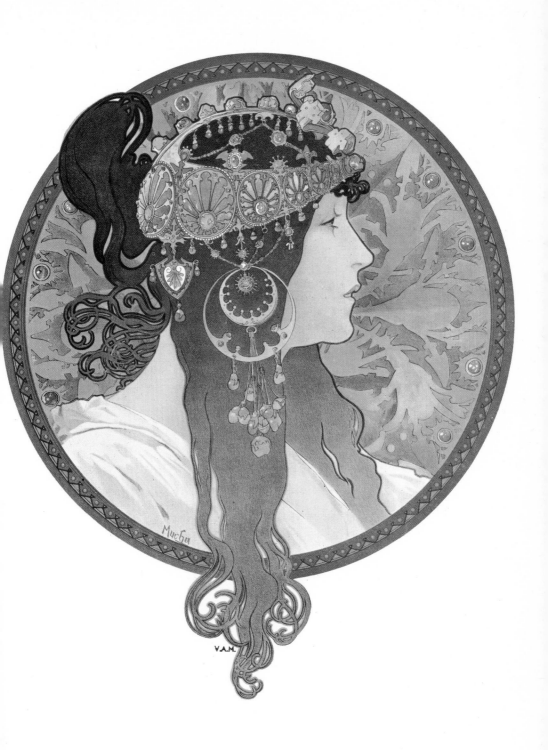

18

LA FLEUR
Panneau
c. 1897
60 x 36 cm / 24 x 14 in

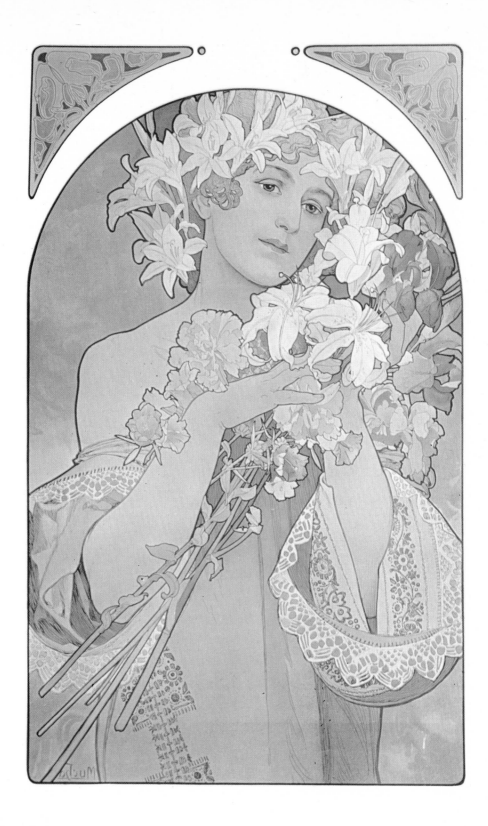

19

LE FRUIT
Panneau
c. 1897
60 x 36 cm / 24 x 14 in

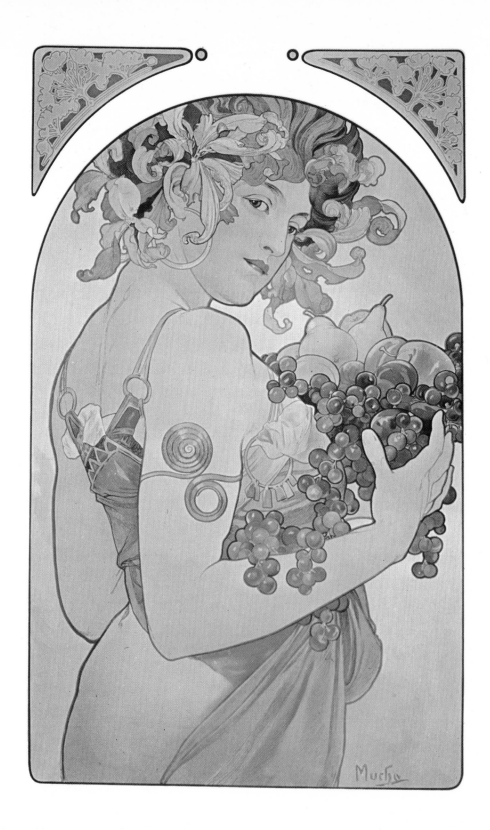

20

EMERAUDE
Panneau
1900
99 x 36 cm / 39 x 14 in

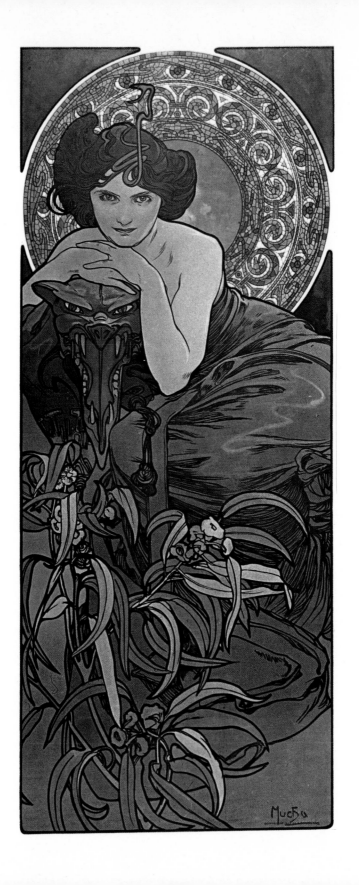

21

AMETHYSTE
Panneau
1900
99 x 36 cm / 39 x 14 in

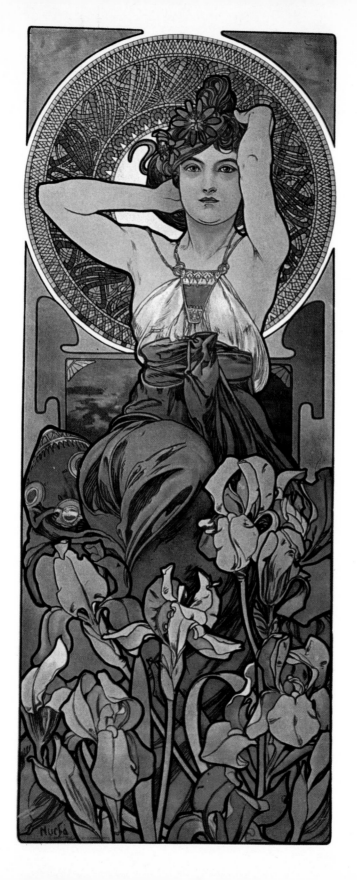

22

RUBIS
Panneau
1900
99 x 36 cm / 39 x 14 in

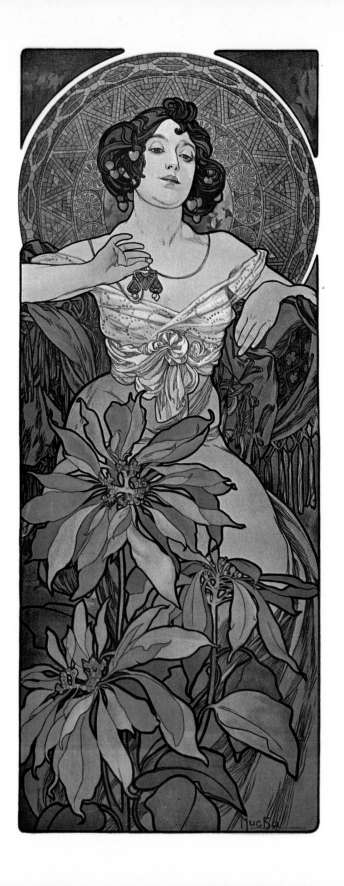

23

TOPAZE
Panneau
1900
99 x 36 cm / 39 x 14 in

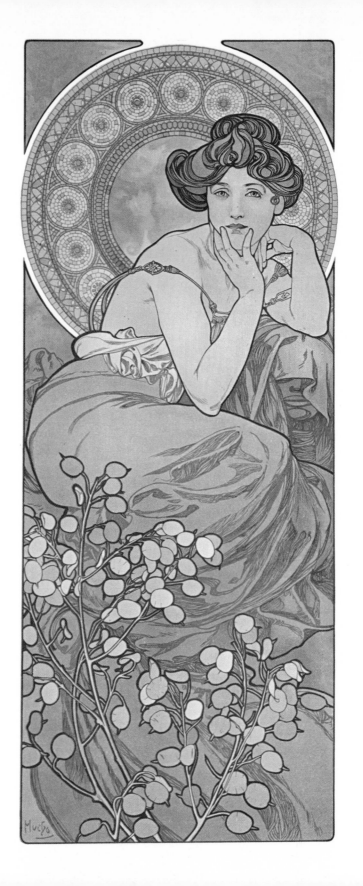

24

PRIMEVERE
Panneau
1899
101 x 36 cm / 40 x 14 in

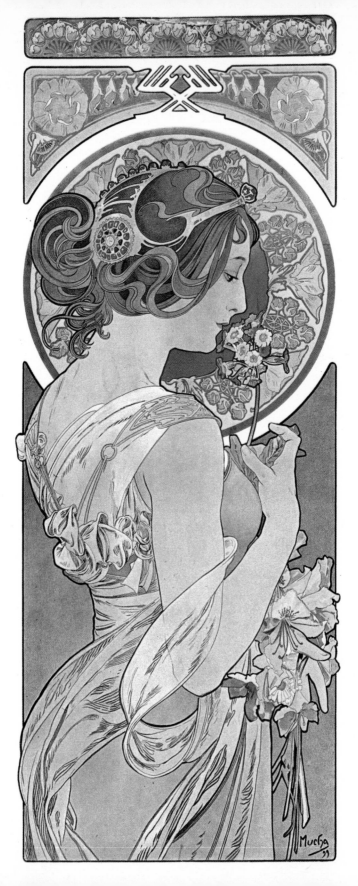

Mucha
99

25

LA PLUME
Panneau
1899
71 x 27 cm / 28 x 11 in

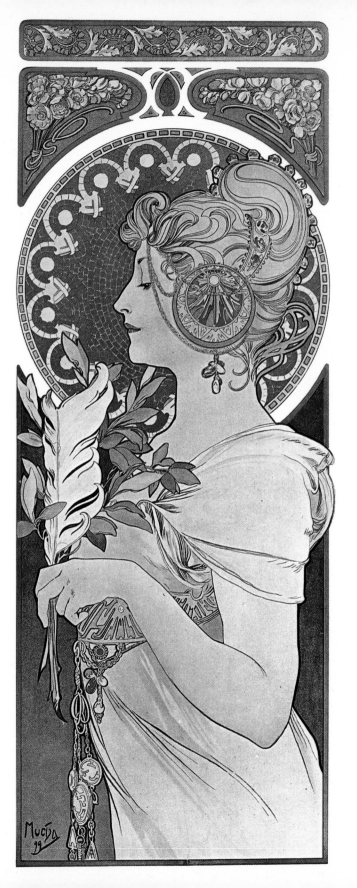

26

ETOILE DU SOIR
Panneau
1902
59 x 23 cm / 23 x 10 in

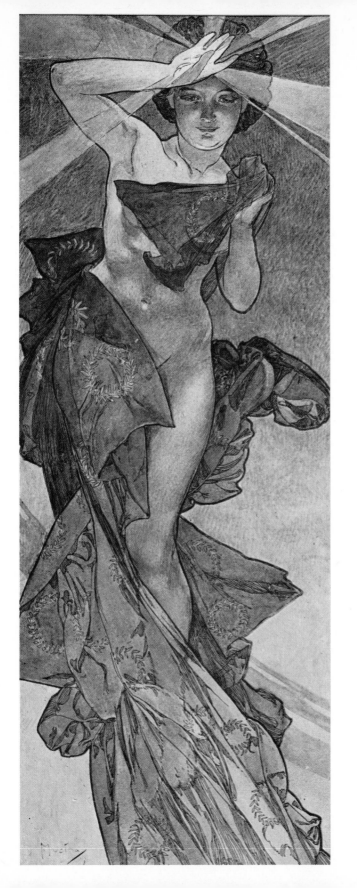

27

LA LUNE
Panneau
1902
59 x 23 cm / 23 x 10 in

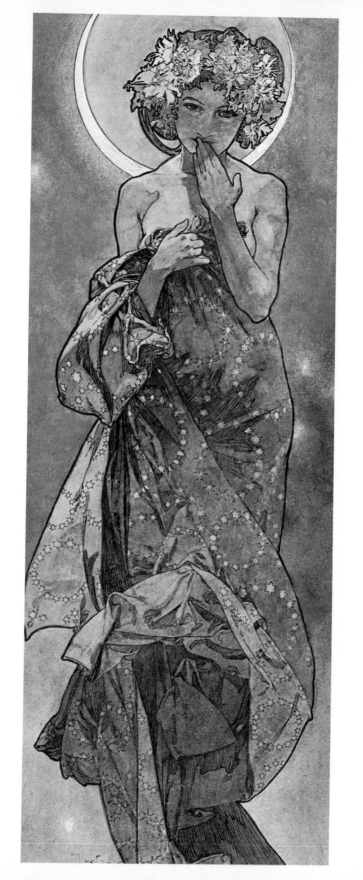

28

L'EVENTAIL
'Le vent qui passe emporte la jeunesse'
1899
26 x 16 cm / 10 x 6 in

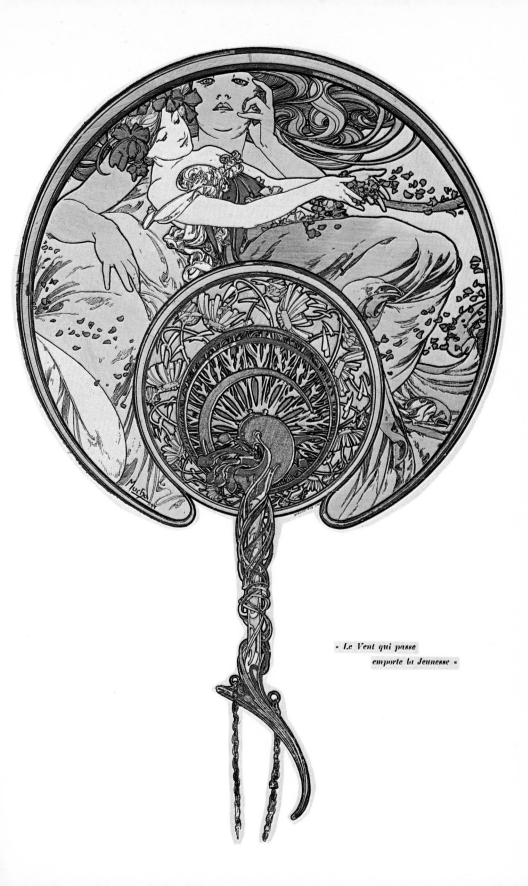

« Le Vent qui passe
emporte la Jeunesse »

29

ROSE
Panneau
1897
100 x 41 cm / 39 x 16 in

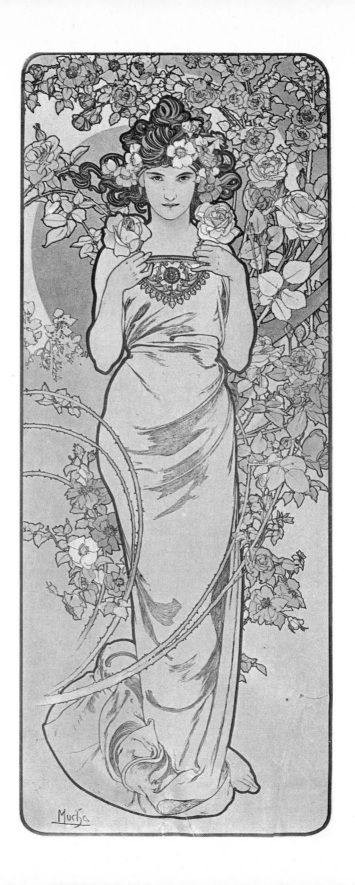

30

IRIS
Panneau
1897
100 x 41 cm / 39 x 16 in

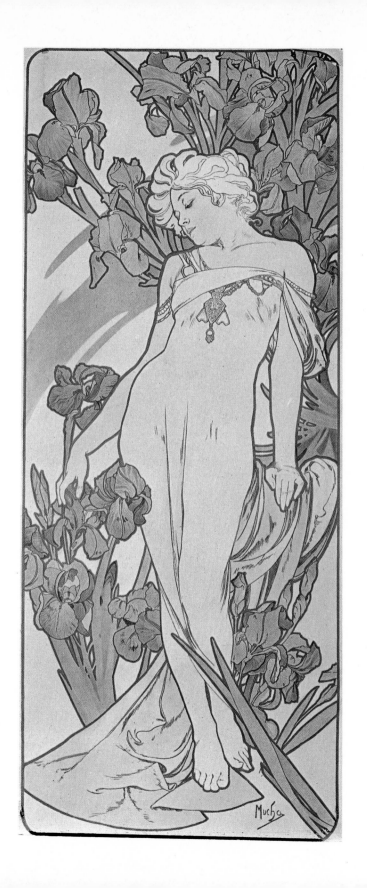

31

LYS
Panneau
1897
100 x 41 cm / 39 x 16 in

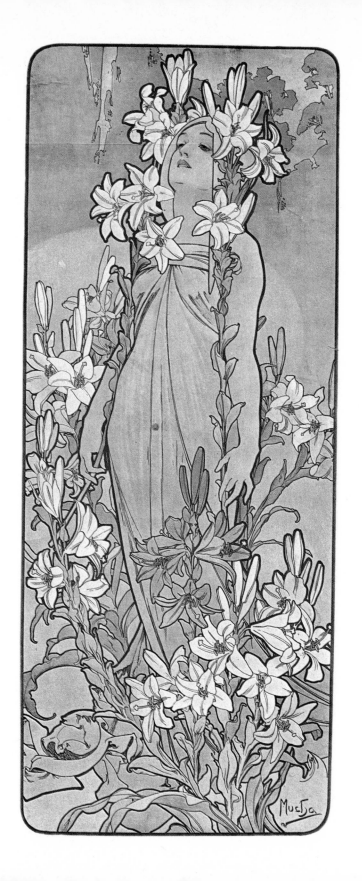

32

OEILLET
Panneau
1897
100 x 41 cm / 39 x 16 in

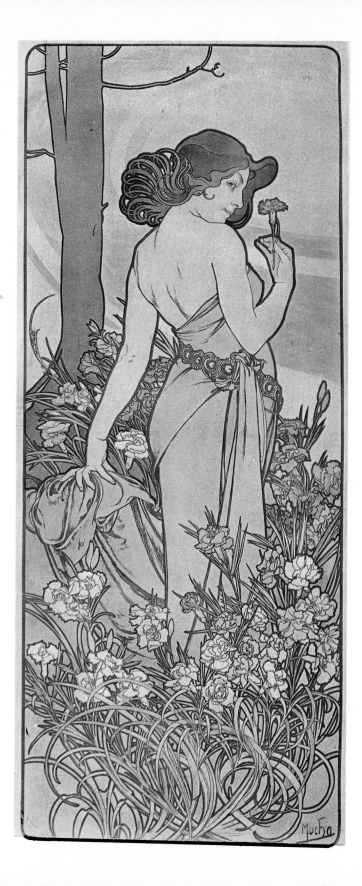

33

ETE
Panneau
c. 1900
70 x 30 cm / 28 x 12 in

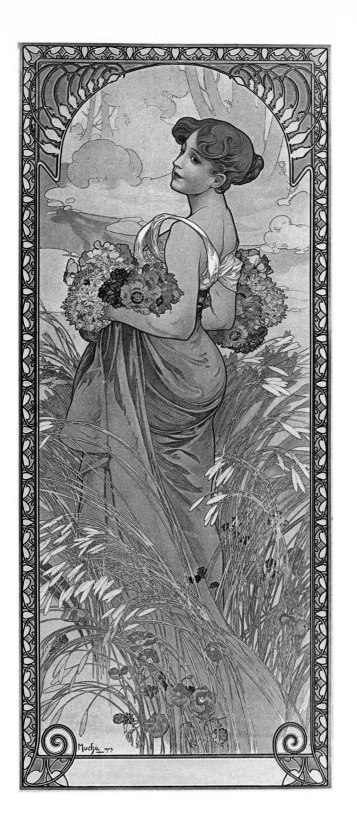

34

AUTOMNE
Panneau
c. 1900
70 x 30 cm / 28 x 12 in

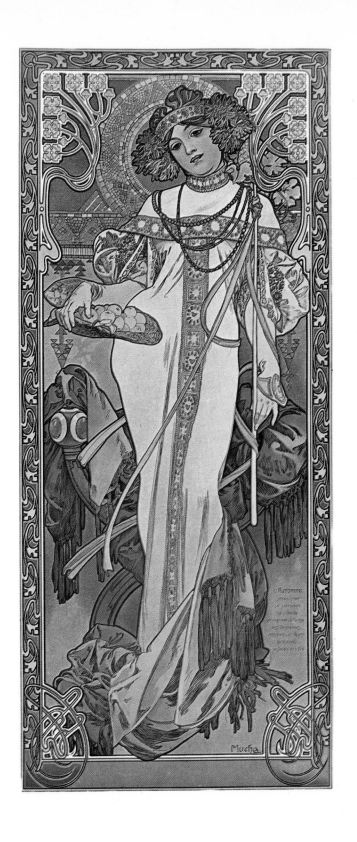

35

LA MUSIQUE
Panneau
1898
56 x 34 cm / 22 x 13 in

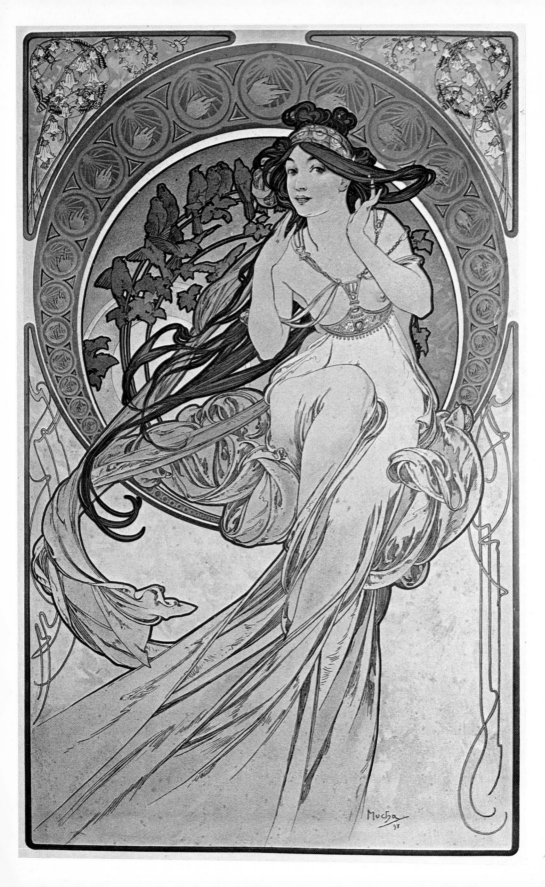

36

LA PEINTURE
Panneau
1898
56 x 34 cm / 22 x 13 in

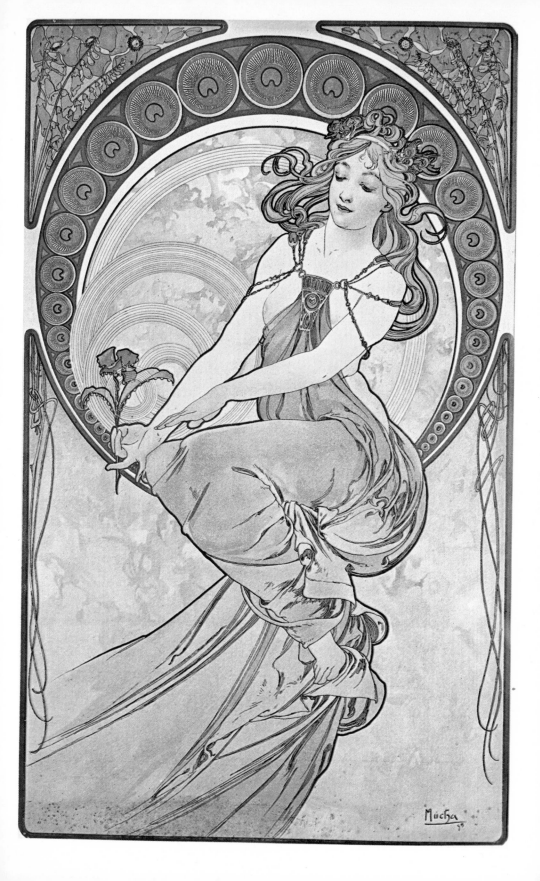

37

LA DANSE
Panneau
1898
56 x 34 cm / 22 x 13 in

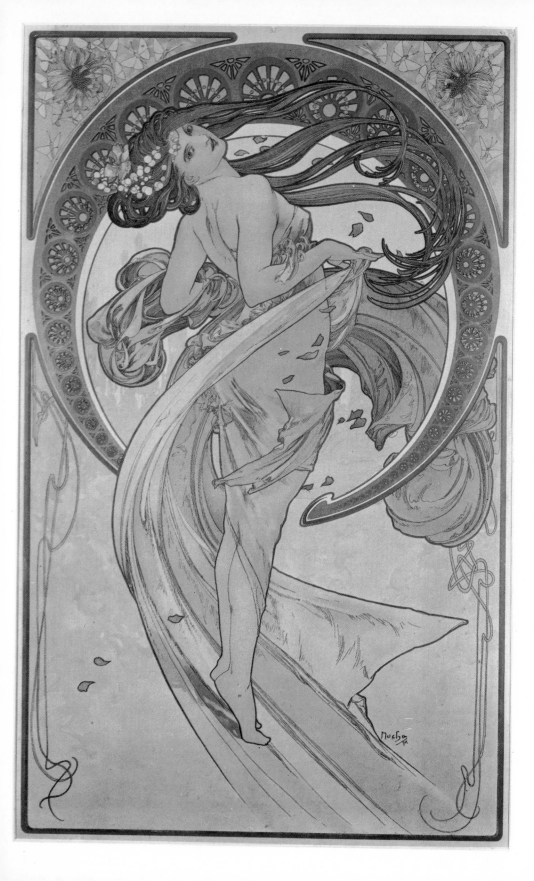

38

LA POESIE
Panneau
1898
56 x 34 cm / 22 x 13 in

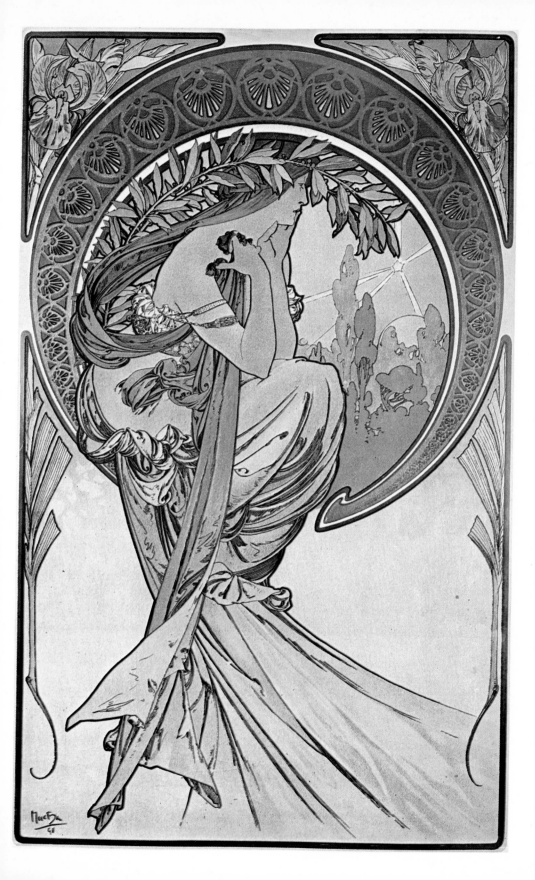

39

DOCUMENTS DECORATIFS
Librairie Centrale des Beaux-Arts
Paris 1902

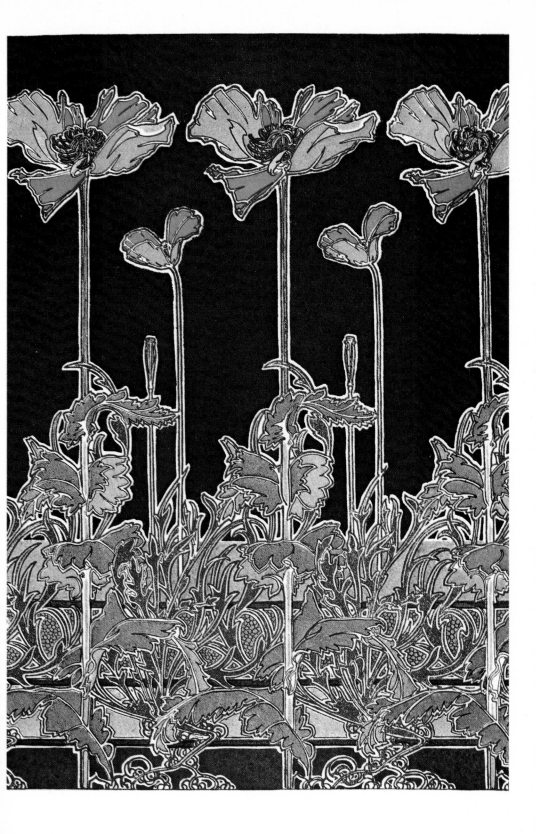

40

FEMME AU CHEVALET
Panneau
1898
63 x 45 cm / 25 x 18 in

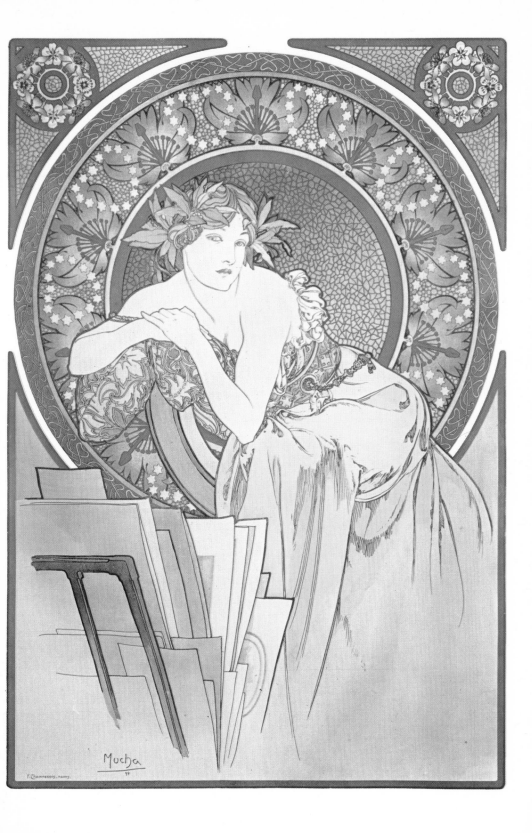

41

LES SAISONS
Panneau
1896
43 x 61 cm / 17 x 24 in

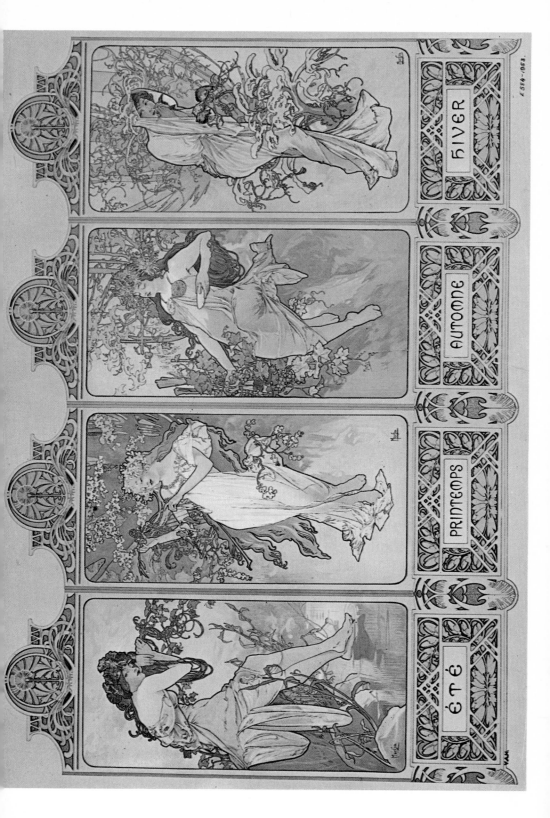

42

FLEUR DE CERISIER
Panneau
1898
21 x 29 cm / 8 x 11 in

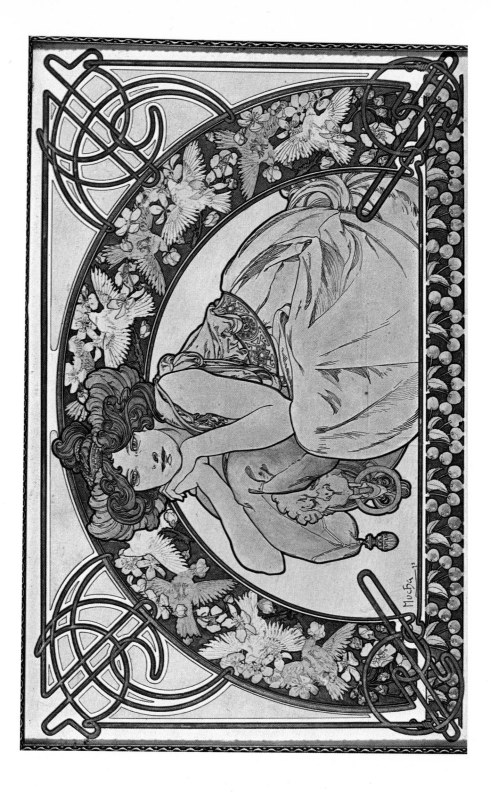

43

NENUPHAR
Panneau
1898
21 x 29 cm / 8 x 11 in

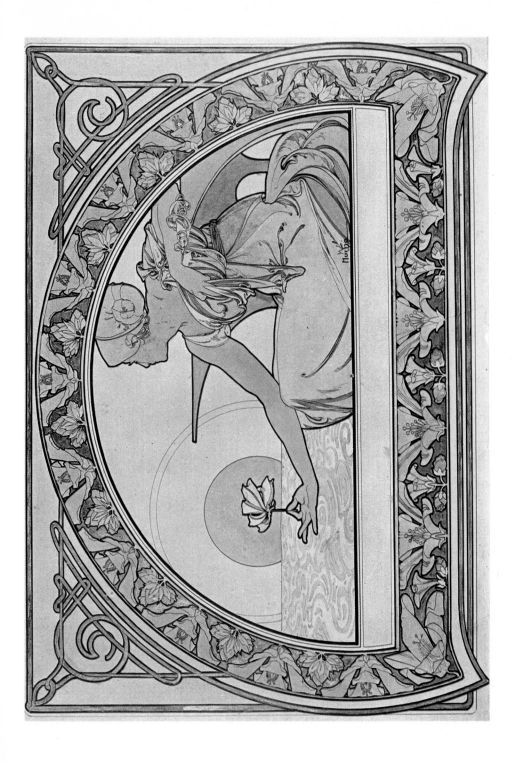

44

LIERRE
Panneau
1901
53 x 39 cm / 21 x 15 in

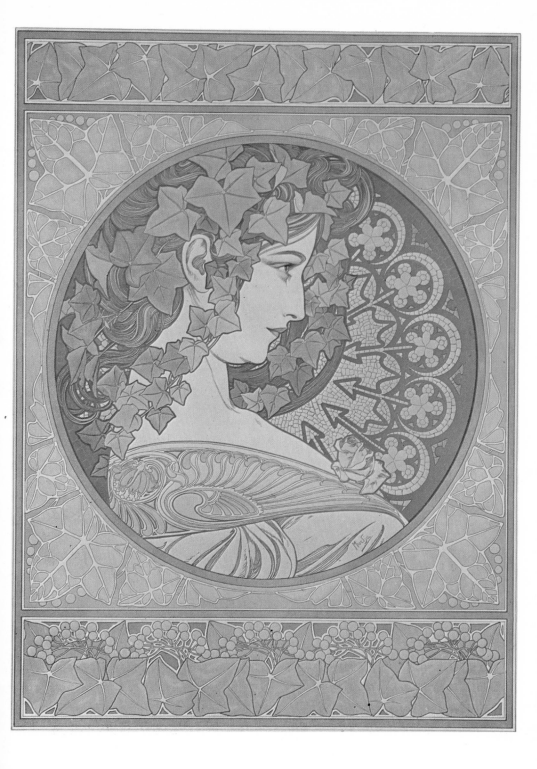

45

LAURIER
Panneau
1901
53 x 39 cm / 21 x 15 in

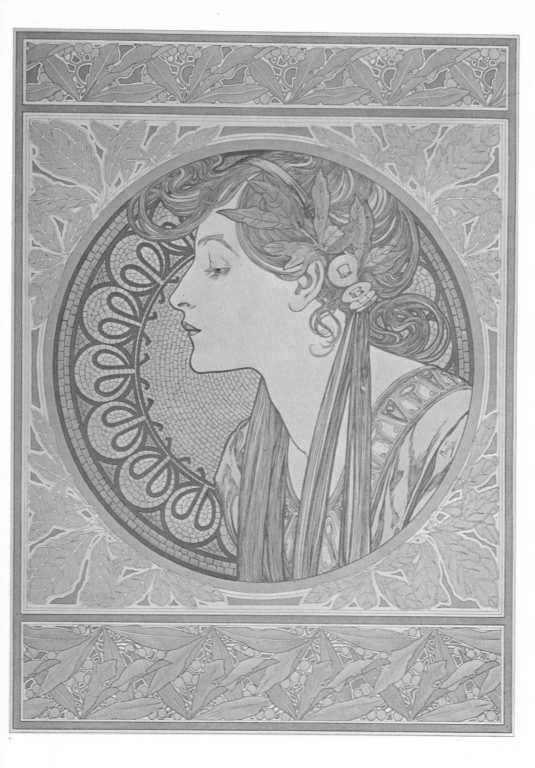

46

THE NEW YORK DAILY NEWS
3.4.1904
48 x 33 cm / 19 x 13 in

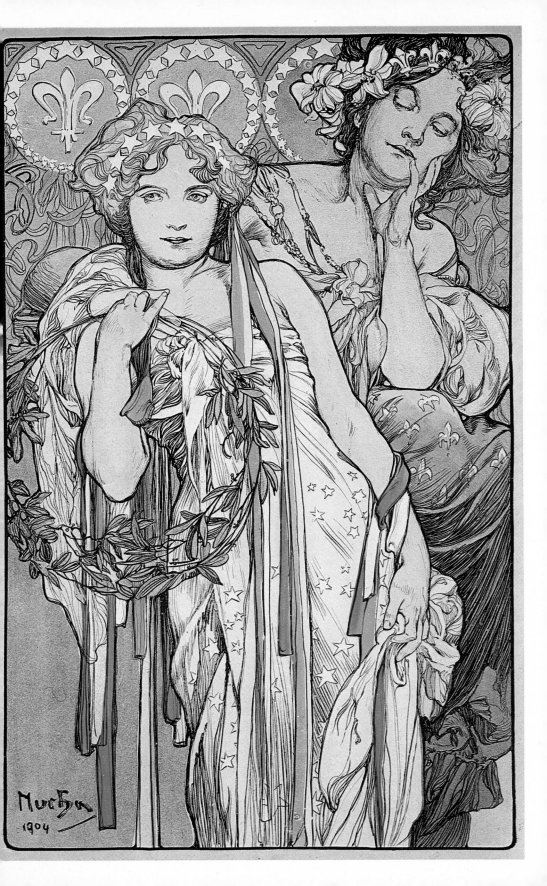

47

AU QUARTIER LATIN
Noel 1900
44 x 31 cm / 17 x 12 in

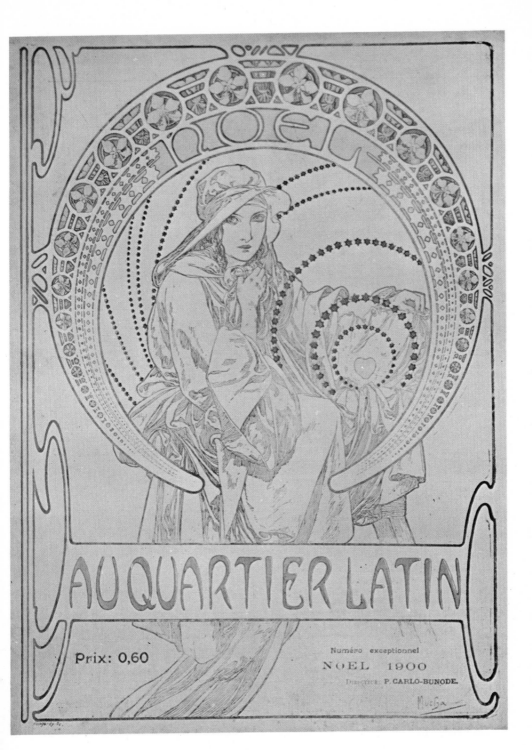

AU QUARTIER LATIN

Prix: 0,60

Numéro exceptionnel

NOEL 1900

Directeur: P. CARLO-BUNODE.

48

HIVER
Panneau
1896
98 x 50 cm / 39 x 20 in

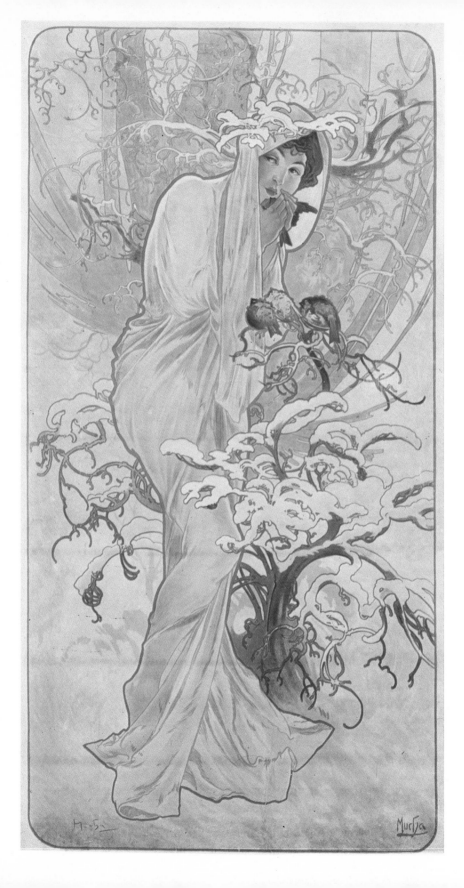